QUIZPEDIA

HANNAH KOELMEYER

90s TV

THE ULTIMATE
BOOK OF TRIVIA

Smith
Street
Books

SO YOU THINK YOU KNOW ...

THE OPRAH WINFREY SHOW

Quiz 01

1.
What city was the home of
The Oprah Winfrey Show?

2.
Which Tuesday guest proved
so popular in the late 90s
that Oprah helped them
launch their own successful
talk show?

3.
Who did Oprah interview
on February 10, 1993, in
what would become the
most-watched TV interview
of all time?

4.
What book was the very
first selected for Oprah's
Book Club?

5.
Oprah withdrew herself and
her show from consideration
for the Daytime Emmys
after receiving what award
in 1998?

6.
Activist Jane Elliott
undertook an anti-racism
experiment that involved
segregating the audience
based on what?

7.
What's the name of Oprah's
production company?

8.
And what connection does
it have to her name?

9.
Discussion of what disease
lead to Oprah being sued
for defamation, forcing the
show to move taping to
Texas during the trial?

10.
Popular segment "Oprah's
Wildest Dreams" was named
for a song by which superstar
(who Oprah sang onstage
with in 1997)?

SO YOU THINK
YOU KNOW ...

DAYTIME

TALK

SHOWS

Quiz 02

1.
The youngest person to host a syndicated talk show at the time, how old was Ricki Lake when *Ricki Lake* started?

2.
Name the show whose host served in the U.S. Navy and Marine Corps prior to his TV career, retiring with the rank of lieutenant commander?

3.
Which regular cast member of *Beverly Hills, 90210* left to host her own talk show that lasted one season?

4.
What color are Sally Jessy Raphael's trademark glasses?

5.
Which famous unrelated Jones was one of the producers of *The Jenny Jones Show*: a. Terry Jones b. Catherine Zeta-Jones c. Quincy Jones?

6.
Known for her philanthropy during the run of *The Rosie O'Donnell Show*, O'Donnell earned the nickname "Queen of ..."?

7.
True or false? Jerry Springer won a Razzie for his portrayal of a talk show host in the 1998 box office bomb *Ringmaster*.

8.
What is the surname of the titular host of *Maury*?

9.
After *The Joan Rivers Show* ended in 1993, Rivers launched a daily home-shopping show called what?

10.
Which host famously received plastic surgery on his show, including a procedure that had fat syringed from his buttocks and reinjected between his eyebrows?

SO YOU THINK YOU KNOW ...

BEVERLY HILLS, 90210

Quiz 03

1.
In what city did twins Brandon and Brenda Walsh live before moving to Beverly Hills?

2.
What is the name of their new high school?

3.
Which two characters wear the same iconic black-and-white prom dress to the Spring Dance?

4.
Why is Donna not allowed to attend her high school graduation?

5.
Which character's father made his wealth from white-collar crime?

6.
Name the diner where the gang regularly hang out?

7.
Which character was played by the daughter of the show's producer, Aaron Spelling?

8.
At the end of which season does Brenda leave for London?

9.
Who was the future Oscar winner who joined the cast in Season 8 as single mom, Carly Reynolds, who starts dating Steve?

10.
Who gets married in the show's final episode?

SO YOU THINK
YOU KNOW ...

MY SO-CALLED LIFE

"FIELD TRIPS ARE
SO INTENSE"

Quiz 04

1.
My So-Called Life takes place in Three Rivers, a fictional suburb of what city?

2.
What is the full name of the character played by Jared Leto?

3.
Playing 15-year-old Angela Chase, how old was Claire Danes when the pilot episode was filmed?

4.
True or false? Amy Adams auditioned for and was almost cast as Angela Chase.

5.
Angela's dad, Graham, gives her and Rayanne tickets to see which band (which Angela later scalps to pay for her fake ID)?

6.
Jordan and Tino's band is called the "Frozen ...": a. Fingers b. Embryos c. Ghosts?

7.
Series creator Winnie Holzman went on to be nominated for a Tony Award for writing what Broadway musical?

8.
What drug, other than alcohol, does Rayanne overdose on at a house party?

9.
How many seasons did My So-Called Life run for?

10.
Which character was shown to be homeless in the Christmas episode?

SO YOU THINK YOU KNOW ...

FREAKS AND GEEKS

Quiz 05

1.
The show was developed by which two people who have gone on to become successful Hollywood directors?

2.
Lindsay begins the series as a geek and is a star in what competitive academic club?

3.
Which of Lindsay's relatives passes away shortly before the series begins, contributing to her disillusionment?

4.
What instrument does Jason Segel's character Nick play in the band Creation?

5.
For Halloween, Bill dresses as Jaime Sommers, the titular character from what TV show?

6.
Who plays Kim Kelly?

7.
When he's caught trying to pull the fire alarm (in an attempt to get out of a test), Daniel is forced to join the A/V club. The geeks enlist him to join what game?

8.
Who has a crush on Cindy Sanders for most of the series?

9.
Neal's dad pressures him into what type of disastrous performance at an anniversary dinner party: a. stand-up comedy b. magic c. ventriloquism?

10.
In the final episode, Lindsay leaves town to follow what band?

DAWSON'S CREEK

"EDGE IS FLEETING.
HEART LASTS FOREVER."

Quiz 06

1.
Dawson has aspirations to become what type of artist?

2.
What is the name of the fictional Massachusetts town where *Dawson's Creek* takes place?

3.
Who does Pacey lose his virginity to?

4.
According to the theme song, what does Paula Cole not want to wait for?

5.
Joey's sister Bessie runs what restaurant that burns down in Season 2?

6.
Jen moved from what city to live with Grams?

7.
What is the last name of siblings Jack and Andie?

8.
Joey sings a song from what musical when she enters a local beauty pageant?

9.
What is Pacey's dad's occupation?

10.
The pilot episode opens with Joey and Dawson watching what movie?

SO YOU THINK
YOU KNOW ...

TEEN
SHOWS

Quiz 07

1.
Hang Time is about the exploits of the Deering Tornados, a high school team who play what sport?

2.
Parker Lewis can't what?

3.
What type of drink does *Kenan & Kel*'s Kel love?

4.
Fred Savage starred in *The Wonder Years* in the 80s. In what show did his brother Ben Savage star in the 90s?

5.
In *Saved by the Bell*, by what name was Samuel Powers better known?

6.
Which two members of the *That '70s Show* main cast are now married to each other?

7.
Brittany Daniel and Cynthia Daniel starred in this adaptation of the hit series of books by Francine Pascal.

8.
What type of pet does Clarissa keep in a sandbox in her room in *Clarissa Explains it All*?

9.
Salute Your Shorts takes place: a. at summer camp b. on a cruise ship c. on an army base?

10.
Who plays the lead in *Blossom*?

SO YOU THINK
YOU KNOW ...

NORTHERN
EXPOSURE

Quiz 08

1.
The show is set in the fictional small town of Cicely, located in what U.S. state?

2.
From what city did Dr. Joel Fleischman move?

3.
Who plays philosophical radio DJ and ex-con Chris Stevens?

4.
Which character is a multi-millionaire businessman and owner of the radio station?

5.
The show's opening credits feature what animal roaming the streets of Cicely?

6.
A falling what kills Maggie's boyfriend Rick?

7.
What is the name of Holling's bar, frequented by Cicely's locals?

8.
Aspiring filmmaker Ed is occasionally visited by a spirit guide – what is his name: a. One Who Waits b. One Who Speaks c. One Who Sees?

9.
Chris is fired from the radio station after discussing the sexuality of which American poet?

10.
Marilyn dabbles in farming what type of bird?

SO YOU THINK
YOU KNOW ...

ER

"WE'RE GONNA TAKE
CARE OF THAT"

Quiz 09

1.
What is the name of the hospital in *ER*?

2.
True or false? The show was created by Michael Crichton, author of *Jurassic Park*.

3.
Who played the role of John Carter?

4.
What was distinctive about the premiere episode of the fourth season, "Ambush"?

5.
Which member of the nursing team attempts suicide in Season 1?

6.
Carla and which doctor have a baby named Reese who is deaf?

7.
Who was the guest director of Season 1's penultimate episode, "Motherhood":
a. Steven Spielberg
b. Quentin Tarantino
c. Ridley Scott?

8.
Mark and Doug go on a road trip to which state to collect Doug's father's remains?

9.
In the multiple Emmy-winning episode "Love's Labor Lost", a pregnant woman suffers from what, leading to a tragic outcome?

10.
Which actor's departure from the show occurs across a two-part episode called "The Storm"?

PRIDE AND PREJUDICE

"DEAREST, LOVELIEST ELIZABETH!"

Quiz 10

1.
Who wrote the screenplay for this acclaimed 1995 adaptation of Jane Austen's classic?

2.
How many episodes are there in the miniseries?

3.
In what country was actress Jennifer Ehle, who plays Elizabeth Bennet, born and raised?

4.
Name all five Bennet sisters.

5.
In what series of movies did Colin Firth play Mark Darcy, a character directly inspired by his portrayal of Mr. Darcy in the series?

6.
What is the name of the grand estate rented by Bingley?

7.
Which actress in the show is actually related to Jane Austen?

8.
True or false? The scene where Mr. Darcy jumps into the lake does not appear in the original novel.

9.
Actress Julia Sawalha was well-known at the time for her famously dull and conservative character (the opposite of Lydia Bennet) in what 90s sitcom?

10.
What is the name of Mr. Collins' gracious and benevolent patron?

SO YOU THINK
YOU KNOW ...

BAYWATCH

Quiz 11

1.
What color are the lifeguards' iconic bathing suits?

2.
The first nine seasons of the show were set in which U.S. state?

3.
Performed by Jimi Jamison, what was the title of the show's theme song?

4.
Which character was killed in Season 7 when lightning strikes a ship causing the mast to fall?

5.
What was the name of the supernatural *Baywatch* spin-off series in which Mitch moonlights as a P.I. with his friends Garner and Ryan?

6.
Pamela Anderson's character C.J. Parker has a part-time job coaching what sport?

7.
True or false? Tom Selleck was offered the role of Mitch but turned it down.

8.
Which Academy Award nominee made her screen debut as a young woman who seduces Mitch's son, Hobie?

9.
Which actress joined the show in Season 4 as Caroline Holden: a. Yasmine Bleeth b. Heather Locklear c. Carmen Electra?

10.
Which original TV series character played by David Charvet was reprised by Zac Efron in the 2017 film?

SO YOU THINK
YOU KNOW ...

DRAMA

Quiz 12

1.
What is the surname of the orphaned siblings in *Party of Five*?

2.
What was in the middle of the *Melrose Place* courtyard?

3.
The star of which popular drama received major fan backlash when her character cut her curly hair short at the beginning of its second season?

4.
How old was Doogie Howser M.D. when he aced the SATs: a. 6 b. 8 c. 10?

5.
Who is the star of *Dr. Quinn, Medicine Woman*?

6.
What was the name of Tony Soprano's psychiatrist?

7.
True or false? The third season of the David E. Kelley series *Picket Fences* included an episode about cows giving birth to human babies.

8.
How many members are there in *7th Heaven*'s Camden family?

9.
What is the medical drama that starred Tony Award-winner Mandy Patinkin as Dr. Jeffrey Geiger?

10.
Who is *The West Wing*'s fictitious U.S. president?

SO YOU THINK YOU KNOW ...

TV

COUPLES

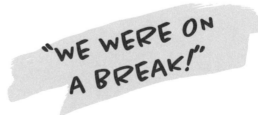

"WE WERE ON A BREAK!"

Quiz 13

1.
In *Friends*, what character does Rachel dress up as to indulge Ross' fantasy?

2.
In the pilot episode of *Felicity*, the titular character follows her crush, Ben, to what city?

3.
What jewelry does Angel give Buffy on her 17th birthday?

4.
In *ER*, how does Carol tell Doug that she is pregnant with twins: a. she leaves him an answering machine message b. she sends him a fax c. she sends him an email?

5.
In *Sex and the City*, when Big reveals he is moving to Paris, Carrie comes to his door wearing a beret holding what brand of fast food?

6.
When Xena and Gabrielle kiss on the spirit plane, whose body is Xena inhabiting in the real world?

7.
What is the name of Jamie and Paul's daughter in *Mad About You*?

8.
In *The X-Files* canon, Mulder and Scully's first "official" kiss occurs on New Year's Eve as it ticks over to what year?

9.
In what season of *The Nanny* does Mr. Sheffield finally propose to Fran (without taking it back)?

10.
During what event does Topanga propose to Cory in *Boy Meets World*?

LAW & ORDER

"THESE ARE THEIR STORIES"

Quiz 14

1.
Aside from the pilot, who is the show's original District Attorney?

2.
Which of the detectives had been married to a flight attendant named Marge?

3.
The police elements of the show revolved around the New York City Police Department – what organization is featured in the legal parts?

4.
Who is the creator of the series (and its many spin-offs)?

5.
True or false? *Law & Order* was filmed in Georgia, with Atlanta standing in for New York City.

6.
Which character, played by Carolyn McCormick, was introduced in Season 2 due to a lack of female characters in the show?

7.
Which of the show's original cast members went on to have a recurring role in *Sex and the City*?

8.
Which member of Lennie Briscoe's family was shot in the head by a meth dealer?

9.
Premiering in 1999, what was *Law & Order*'s first spin-off series?

10.
Which Academy Award winner joined the cast in Season 8 as Dr. Emil Skoda, a psychiatrist who worked with the police department?

SO YOU THINK
YOU KNOW ...

NYPD BLUE

Quiz 15

1.
The detective squad works in what Manhattan precinct?

2.
In what season did Jimmy Smits join the cast as Det. Bobby Simone?

3.
Actress Kim Delaney plays which role?

4.
Det. Andy Sipowicz is a veteran of which war?

5.
True or false? Actor Gordon Clapp (Det. Greg Medavoy) was a real-life NYPD detective before retiring to pursue an acting career.

6.
Which series creator went on to make the beloved HBO Western *Deadwood*?

7.
Mob boss Angelo Marino orders Janice Licalsi, John Kelly's girlfriend, to kill Kelly. What does Janice do?

8.
PAA Donna Abandando leaves the department to take a job at which tech company?

9.
Who is the bigoted borough commander who makes numerous attempts to ruin Capt. Arthur Fancy's career?

10.
What is the name of Sipowicz and Sylvia's baby?

ALLY
MCBEAL

"I LIKE BEING A MESS.
IT'S WHO I AM."

Quiz 16

1.
In what city was
Ally McBeal set?

2.
What is the name of the
fictional law firm at the
center of the show?

3.
What is unusual about
the firm's restroom?

4.
What was Nelle's nickname
before she joined the firm?

5.
Who is the actress who
plays the cold and ferocious
Ling Woo?

6.
In order to perform
competently in court, John
Cage draws inspiration from
what legendary R&B artist?

7.
Notable for featuring
character dream sequences
and hallucinations, the most
famous was Ally's vision of
a dancing what?

8.
And what is the song
performed by one-hit-
wonder Blue Swede that
it dances to?

9.
When she starts at the firm,
Ally is horrified to discover
she'll be working alongside
her ex, whom she's not over.
What is his name?

10.
Enterprising office assistant
Elaine Vassal creates a
number of inventions
including a bra for what
part of the body?

SO YOU THINK YOU KNOW ...

LEGAL & CRIME DRAMAS

Quiz 17

1.
JAG is about a legal team who deal with what type of crimes?

2.
Silent Witness' Sam Ryan is:
a. a forensic photographer
b. a forensic pathologist c. a forensic ballistics expert?

3.
Taking place in the same fictional universe as *Law & Order*, what show was notable for being the first police drama on American TV to feature two people of color in the starring roles?

4.
The closing credits of *The Bill* depicted what?

5.
A series about an unconventional policeman initially based on the novels by R. D. Wingfield:
A Touch of …?

6.
Also known for *Ally McBeal*, who is the series creator of *The Practice*?

7.
Who is the star of *Walker, Texas Ranger*?

8.
Which two actors who appeared in *Murder One* went on to star in two films together, *Blind Date* and *Easy A*?

9.
For what type of food does *Matlock*'s titular criminal defense attorney have a particular fondness?

10.
True or false? *Homicide: Life on the Street* was based on a book by Baltimore journalist David Simon, who would go on to create *The Wire*.

SO YOU THINK
YOU KNOW ...

SOAP
OPERAS

Quiz 18

1.
One of the longest-running scripted television programs in the world, which show famously begins with the words: "Like sands through the hourglass ..."

2.
What industry does *The Bold and the Beautiful* mostly revolve around?

3.
In what street is *Neighbours* set?

4.
What medical-themed show is listed in Guinness World Records as the longest-running American soap opera in production?

5.
Debuting in 1999, *Passions* followed the lives and paranormal adventures of the residents of what fictional New England town?

6.
On the air since 1964, which show ended in 1999 with an episode revolving around the wedding of Cass Winthrop and Lila Roberts?

7.
Which show revolved around the wealthy Californian Capwell family?

8.
Kimberlin Brown's Sheila Carter was a crossover character in *The Bold and the Beautiful* and what other show?

9.
EastEnders is set in what city?

10.
True or false? Debuting in 1937 as a radio show, *Guiding Light* is primarily set in a Vermont lighthouse and its surrounding community.

SO YOU THINK YOU KNOW ...

THE FRESH PRINCE OF BEL-AIR

"YO HOLMES, SMELL YA LATER."

Quiz 19

1.
According to the theme song, where was Will "born and raised" before being sent to live with his aunt and uncle in Bel-Air?

2.
How many actresses played the role of Aunt Vivian during the show's original run?

3.
Which character is regularly physically thrown from the Banks' mansion by Uncle Phil?

4.
What song is Carlton's signature for performing his iconic dance moves?

5.
Which Academy Award nominee had a recurring role as Will's friend Ice Tray?

6.
Why does Geoffrey, the Banks' butler, quit his job in a Season 3 episode?

7.
Hilary's boyfriend is killed when proposing to her while: a. skydiving b. bungee jumping c. roller blading?

8.
When Will gets a job as a waiter, what costume is he required to wear?

9.
True or false? Ashley Banks becomes a one-hit wonder with a song called "What's Up, Will".

10.
Nicky Banks' last four middle names are the names of the members of which band, who performed at his christening?

THE

NANNY

"OH, MR. SHEFFIELD!"

Quiz 20

1.
According to the show's theme song, Fran Fine was hired because she had style, she had flair ... and what was the third reason?

2.
What is the name of the Sheffields' wise-cracking butler?

3.
How many children are there in the Sheffield household at the beginning of the show?

4.
Played by Fran Drescher's real-life pet dog, Chester belongs to which character?

5.
Which legendary musician appeared in four episodes of *The Nanny* as Grandma Yetta's love interest?

6.
What is Maxwell Sheffield's middle name: a. Beverley b. Clover c. Aubrey?

7.
How does Fran commonly refer to the situation in which Maxwell told her he loved her ... and then took it back?

8.
True or false? Sylvia Fine, Fran's mother, is played by Drescher's real-life mother Sylvia Drescher.

9.
Who is Fran's best friend who worked with her in the bridal shop before they both got fired?

10.
What was the Broadway smash hit that Maxwell passed on producing early in his career (and has haunted him ever since)?

EVERYBODY LOVES RAYMOND

Quiz 21

1.
Everybody Loves Raymond
is about an Italian-American
extended family with
what surname?

2.
What does Robert,
Raymond's brother,
do for a job?

3.
What are the names of
Ray and Debra's twins?

4.
In Season 1, Marie decides to
leave Frank after a fight over
what type of sandwich?

5.
Robert has a quirk of
touching food to what part
of his face before eating it?

6.
True or false? Before
becoming a housewife,
Debra was pursuing a career
in professional baseball.

7.
Ray is a sportswriter for
which newspaper?

8.
What was Ray delivering to
Debra's apartment when
they first met?

9.
What does Frank
accidentally hand out to kids
instead of Halloween candy?

10.
All of the adult cast
members won multiple
Emmys for their work on the
show except for which actor,
who was nominated seven
times but never won?

FAMILY SITCOMS

Quiz 22

1.
Full House's Danny Tanner is the co-host of what local breakfast TV show: a. *Golden Morning, Golden Gate* b. *San Fran Daily* c. *Wake Up, San Francisco*?

2.
Which show starred Joey Lawrence, with his real-life brothers Matthew and Andrew occasionally appearing in flashbacks as younger versions of his character?

3.
And name the show starring all three Lawrence brothers in lead roles?

4.
Sister, Sister is about identical twins Tia and ... who were separated at birth and reunited as teenagers.

5.
Family Matters was a spin-off of which 80s sitcom?

6.
What is Tim Taylor's nickname in *Home Improvement*?

7.
According to *Married ... with Children*'s theme song, what do love and marriage go together like?

8.
Who is the singer who played the title role in *Moesha*?

9.
A riff on *The Brady Bunch*, *Step by Step* is about single parents who form a blended family. Starring Patrick Duffy as Frank and who as Carol?

10.
Who is Cory's love interest in *Boy Meets World*?

SO YOU THINK
YOU KNOW ...

SEINFELD

"HELLO, NEWMAN"

Quiz 23

1.
What is Kramer's first name?

2.
What type of candy falls into Elaine's boyfriend Roy's body during surgery?

3.
Which character uses the fake name Art Vandelay?

4.
In the episode "The Switch", what is it that Jerry wants to switch?

5.
Celebrated on December 23, a main feature of Festivus is the airing of what?

6.
During what movie was Jerry caught making out?

7.
What was Peterman's mother's last word?

8.
George and Jerry have a conversation about what in both the pilot episode and the finale?

9.
What is exposed in Elaine's Christmas card?

10.
Who had a recurring role on *Seinfeld* as dentist Tim Whatley?

ABSOLUTELY

FABULOUS

Quiz 24

1.
Absolutely Fabulous was based on the "Modern Mother and Daughter" sketch from what show?

2.
Played by Jane Horrocks, what is the name of Edina's brainless personal assistant?

3.
What is Patsy and Edina's favorite brand of Champagne?

4.
In the episode "Morocco", who does Patsy sell to slave traders?

5.
What is Edina's main occupation?

6.
When was the last time Patsy ate: a. 1973 b. 1969 c. 1985?

7.
True or false? Kylie Minogue released a version of the show's theme song "This Wheel's On Fire" for the soundtrack of *Absolutely Fabulous: The Movie*.

8.
Patsy claims to be so influential in the fashion world that, "One snap of my fingers and I can raise hemlines so high that the world is your ..." what?

9.
Who is the British singer who appears as God on a French ski slope after Edina has a near-death experience?

10.
During an impassioned speech in court in the episode "Poor", who does Edina argue should be taxed?

SO YOU THINK
YOU KNOW ...

FRIENDS

"OH ... MY ... GOD!"

Quiz 25

1.
What did Ross call his pet monkey?

2.
Why does Chandler hate Thanksgiving?

3.
What is the name of Phoebe's twin?

4.
What is Joey's fake name?

5.
What does Monica lose when she and Rachel are unable to name Chandler's job?

6.
In "The One Where Rachel Finds Out", what does Rachel find out?

7.
Before working at Central Perk, Gunther had a career as: a. a mortician b. a meteorologist c. an actor?

8.
What type of toy is a key feature of the Geller Cup?

9.
By what name is the nude man in the apartment across from Monica's best known?

10.
Who is the legendary actor who played Richard Burke, the handsome ophthalmologist that Monica dates who is 21 years her senior?

FRASIER

"YOU THINK I'M PRETENTIOUS?"

Quiz 26

1.
Frasier is set in what
U.S. city?

2.
True or false? Kristin
Scott Thomas guest
starred as Niles' first wife,
Maris Crane.

3.
What does Frasier say
when he answers a call on
his radio show?

4.
What are the call letters of
Frasier's radio station?

5.
Where is Daphne
originally from?

6.
Frasier and Niles
frequent what cafe?

7.
What was the name of
the apartment complex
where Frasier lived?

8.
Frasier is a spin-off of
what TV show?

9.
Roz's mom holds what
public office?

10.
What is the name of
Martin Crane's dog?

SO YOU THINK
YOU KNOW ...

MR. BEAN

Quiz 27

1.
Mr. Bean was co-created by the show's star, Rowan Atkinson, and which legendary British screenwriter?

2.
What is the name of Mr. Bean's teddy bear: a. Freddie b. Teddy c. Edmund?

3.
What does Mr. Bean lose inside the Christmas turkey?

4.
With no privacy on the beach, Mr. Bean tries to change into his swimsuit without first removing his clothing. Why was this unnecessary?

5.
What type of car does Mr. Bean drive?

6.
On his birthday, what does Mr. Bean order for dinner at the restaurant?

7.
Mr. Bean has a long-running feud with the unseen driver of a pale-blue Reliant Regal. What is unique about this car?

8.
After "rescuing" a baby at an amusement park, where does Mr. Bean fall asleep?

9.
True or false? Mr. Bean doesn't speak during the show.

10.
When preparing a fish sandwich in the park, how does Mr. Bean dry his lettuce?

WILL &
GRACE

"YOU SAY POTATO,
I SAY VODKA"

Quiz 28

1.
What is Grace Adler's occupation?

2.
Grace moves in with Will after breaking up with who?

3.
Who guest starred as Grace's mom, Bobbi Adler?

4.
What is the name of Jack's pet macaw, who Karen accidentally lets out a window?

5.
Which university did Will graduate from?

6.
Who does Rosario marry to keep her green card?

7.
True or false? Will and Grace dated in college.

8.
What is the name of Will's ex-boyfriend whose apartment Grace is hired to decorate?

9.
What springs several leaks while Grace is on a date at an art gallery?

10.
What is the name of Karen's wealthy (and mostly unseen) husband?

SO YOU THINK
YOU KNOW ...

SITCOMS

Quiz 29

1.
Who played the title role in NBC's *Suddenly Susan*?

2.
David Cross guest starred on *Just Shoot Me* as Elliot's brother Donnie. What type of food does he sing about?

3.
In what city does *The Drew Carey Show* take place?

4.
Queen Latifah's character Khadijah James is the editor and publisher of what magazine in *Living Single*?

5.
On what number date do Dharma and Greg get married?

6.
Hangin' with Mr. Cooper's titular teacher coaches what high school sport?

7.
What public office is held by Michael J. Fox's character Mike Flaherty in *Spin City*?

8.
Name the comedian who starred in *Martin*.

9.
True or false? Jerry Seinfeld made a guest appearance on *Mad About You*, playing Paul's cousin who hits on Jamie.

10.
Which member of the *NewsRadio* cast is now the host of one of the world's most popular podcasts?

THEME

SONGS

Quiz 30

1.
What show's theme song refers to "tossed salad and scrambled eggs"?

2.
Name the alt-rock duo who performed the *Friends* theme The world is my toaster!**3.**

True or false? Legendary film and TV composer Danny Elfman, writer of *The Simpsons* theme, has never won an Oscar?

4.
The theme song of what show promised that the titular character would "take pollution down to zero"?

5.
What 90s TV show was added to Netflix in 2020 with "Run Like Mad" by Jann Arden in place of its iconic theme?

6.
South Park's theme song was written and performed by what rock band?

7.
The Grammy-winning theme for what TV show is an instrumental version of "Falling" by Angelo Badalamenti and Julee Cruise?

8.
Love Spit Love's cover of "How Soon Is Now?" by The Smiths is the theme to what show?

9.
"Buffy the Vampire Slayer Theme" was written by:
a. NOFX b. Bikini Kill
c. Nerf Herder?

10.
British band Alabama 3 sing "Woke Up This Morning" as what character drives the New Jersey Turnpike?

SO YOU THINK
YOU KNOW ...

RUGRATS

"THE WORLD IS MY TOASTER!"

Quiz 31

1.
What are the twins' names?

2.
Chuckie wears a red and blue T-shirt with a picture of what on it?

3.
What is Tommy's dad's job?

4.
How are Tommy and Angelica related?

5.
True or false? Devo singer/keyboardist and frequent Wes Anderson collaborator Mark Mothersbaugh is the show's composer.

6.
Who is the "fraidy cat"?

7.
Appearing in movies and on cereal boxes, ice-skating shows, action figures and other merchandise, what is the name of the Rugrats' beloved dinosaur?

8.
What tool does Tommy often keep stashed in his diaper?

9.
What was the name of the spin-off series that aired in the early 2000s, featuring the *Rugrats* characters as preteens?

10.
Which of the kids' dads is the creator of the cartoon series *The Dummi Bears*?

ANIMANIACS

"NOW THAT'S COMEDY!"

Quiz 32

1.
The siblings live on what studio lot in Burbank, California?

2.
What type of structure do they live in?

3.
According to the show's theme song, they're "zany to the ..."?

4.
Pinky and the Brain do the same thing every night. What is it?

5.
A parody of *Goodfellas*, what is the name of the Italian-American pigeons?

6.
What are the siblings' names?

7.
What color is Slappy Squirrel's hat?

8.
Buttons is a faithful dog who is in constant peril due to an oblivious toddler named what?

9.
Which *Animaniacs* segment got its own spin-off show in 1996?

10.
Which Hollywood director was executive producer, with the show's alternate title being (...) *Presents Animaniacs*?

SO YOU THINK
YOU KNOW ...

KIDS'
CARTOONS

Quiz 33

1.
"Cowabunga!" was the catchphrase of which Teenage Mutant Ninja Turtle?

2.
In *Dexter's Laboratory*, who is the boy genius' archnemesis and rival classmate?

3.
Name the five elements controlled by the Planeteers via their magic rings.

4.
True or false? Jim Carrey reprised his role as Stanley Ipkiss in *The Mask: Animated Series*.

5.
In December 1997, it was reported that more than 600 Japanese children had suffered seizures while watching an episode of what show?

6.
What was the name of the Disney animated series that featured *The Jungle Book*'s Baloo as a cargo freight pilot?

7.
In *Dragon Ball Z*, what is Goku's signature attack?

8.
Which *Star Wars* actor voiced several villains in *Batman: The Animated Series*?

9.
What type of animal is Rocko in *Rocko's Modern Life*?

10.
In *Doug*, Doug's love interest Patti has what food-related surname?

THE
SIMPSONS

"EVERYTHING'S COMING UP
MILHOUSE"

Quiz 34

1.
What secret organization does Homer join in the episode "Homer the Great"?

2.
Name the character who was introduced to *The Itchy & Scratchy Show* in a misguided attempt to appeal to a wider audience.

3.
In "Treehouse of Horror IV", what does Homer state he would sell his soul for?

4.
Complete this phrase: "You'll have to speak up. I'm wearing a ..."

5.
Which late night talk show host wrote several episodes of *The Simpsons* early in his career, including Season 4's "Marge vs. the Monorail"?

6.
Who shot Mr. Burns?

7.
What does Seymour Skinner convince Superintendent Chalmers is the cause of the red glow coming from his kitchen after preparing him a lunch of "steamed hams"?

8.
According to Chief Wiggum, what mythical creature is a horse with the head of a rabbit and the body of a rabbit?

9.
What are the (unmarried) names of Marge Simpson's twin sisters?

10.
Which Beatle counsels Lisa in the episode "Lisa the Vegetarian"?

SO YOU THINK YOU KNOW ...

KING OF THE HILL

Quiz 35

1.
Going on to create the American version of *The Office* and *Parks and Recreation*, *King of the Hill* was co-created by Mike Judge and who?

2.
On the Order of the Straight Arrow camping trip, what type of bird does Bobby stun?

3.
What explodes at the end of Season 2?

4.
The show takes place in Arlen, a fictional town in what state?

5.
What name does Dale Gribble use as an alias, mostly for ordering pizza?

6.
What does Hank sell for a living?

7.
What does Peggy hope to win by entering the Mrs. Heimlich County beauty pageant?

8.
Who guest starred as Luanne's love interest Rad Thibodeaux?

9.
True or false? Boomhauer's unintelligible speech pattern is the result of being bitten in the mouth as a child by a Texas rat snake.

10.
The Hills' dog is a purebred Georgia bloodhound called ...?

DARIA

"I DON'T HAVE LOW SELF-ESTEEM. I HAVE LOW ESTEEM FOR EVERYONE ELSE."

Quiz 36

1.
What is Daria's surname?

2.
Daria is a spin-off of what animated show?

3.
What is the name of Daria and Jane's high school?

4.
Charles Ruttheimer III has what nickname?

5.
Name the rock star who played Jane's pretentious art camp host?

6.
Of what school club is Daria's sister Quinn a member?

7.
Daria and Jane share a mutual love of what TV show?

8.
Jane's brother Trent Lane fronts a band called: a. Mystik Spiral b. Cafe Disaffecto c. Phantasy Phobia?

9.
Daria's parents force her to get a job at the mall selling what?

10.
What body part does Trent charm Daria into getting pierced?

SO YOU THINK
YOU KNOW ...

ADULT
CARTOONS

Quiz 37

1.
Dr. Katz, Professional Therapist was made using animation software invented by the show's producer called:
a. Wireframer b. Motion Motor c. Squigglevision?

2.
True or false? Series creator Mike Judge voiced both Beavis and Butt-Head.

3.
What type of dog is Ren from The Ren & Stimpy Show?

4.
What was the name of MTV's avant-garde series about a secret agent navigating a dystopian future, later adapted into a film starring Charlize Theron?

5.
Voiced by Seinfeld's Jason Alexander, what is the occupation of Duckman's Eric Tiberius Duckman?

6.
The first season of Dilbert focusses on the creation of what new product?

7.
Liquid Television launched several successful cartoons including Beavis and Butt-Head. On what cable channel did it run?

8.
Space Ghost Coast to Coast is a spoof talk show that used animation from an original 1960s Saturday morning cartoon from which studio?

9.
In what fictional Rhode Island city is Family Guy set?

10.
What is the name of the dark and very adult superhero series based on the antihero character Al Simmons, created by Todd McFarlane?

TWIN PEAKS

"THERE'S A SORT OF EVIL OUT THERE"

Quiz 38

1.
What law enforcement agency does Dale Cooper work for?

2.
What was the name of the Canadian casino and brothel where Laura Palmer worked before she died?

3.
Before a change of heart, Twin Peaks' richest citizen Benjamin Horne attempts to develop a luxury country club called what?

4.
By what name is Margaret Lanterman better known?

5.
When Laura's body is discovered, what is it wrapped in?

6.
Also known as the "waiting room", where does Cooper have his dream encounter with the one-armed man?

7.
Brothel madam Blackie O'Reilly hires Audrey after seeing her perform what trick?

8.
Cooper finds a tiny piece of paper under Laura's fingernail with what letter written on it?

9.
One of the clues given to Cooper by The Giant is "There is a man in a ..."?

10.
What is the name of Norma's diner?

SO YOU THINK YOU KNOW ...

BUFFY THE VAMPIRE SLAYER

"IN EVERY GENERATION THERE IS A CHOSEN ONE"

Quiz 39

1.
Sunnydale is built directly on top of what, drawing evil and demonic forces to the town?

2.
Why was Buffy kicked out of her previous school?

3.
Which character has the nickname "Ripper"?

4.
True or false? Buffy meets Angel in the show's first episode.

5.
Who is the new Slayer who arrives in Sunnydale after Buffy (briefly) dies at the end of Season 1?

6.
What is the collective nickname for Buffy and her friends?

7.
Buffy's mom Joyce Summers' occupation is:
a. archaeologist
b. art gallery manager
c. university professor?

8.
What is Buffy's stake called?

9.
What does Angel lose after he sleeps with Buffy?

10.
What are the voice-stealing demons called in the episode "Hush"?

XENA: WARRIOR PRINCESS

Quiz 40

1.
Of what show was *Xena* a spin-off?

2.
What other name was Xena previously known by:
a. Killer of Men
b. Destroyer of Nations
c. Mother of Death?

3.
What is the name of the actor who plays Xena's companion, Gabrielle?

4.
In what country was the show filmed?

5.
The series was produced by film director Sam Raimi. Which of his frequent collaborators played Autolycus?

6.
What is Xena's signature razor-edged throwing weapon called?

7.
Gabrielle begins the series as a simple farm girl but eventually becomes what type of queen?

8.
Lucy Lawless played a number of dual roles, as Xena has many look-alikes. Which of her doppelgangers is the daughter of King Lias?

9.
Conceived via a dark ritual, Gabrielle gives birth to a child which she names what?

10.
What is the name of Xena's first trusty steed?

SO YOU THINK
YOU KNOW ...

FANTASY

Quiz 41

1.

In *Touched by an Angel*, Monica is a recently promoted angel. Who is her sarcastic-but-caring supervisor?

2.

On what birthday does Sabrina the Teenage Witch discover her powers?

3.

In *Hercules: The Legendary Journeys*, who is Hercules' primary nemesis (as mentioned in the show's opening narrative)?

4.

Goosebumps is an anthology horror series based on the best-selling books by ...?

5.

Who played the title roles in *Lois & Clark: The New Adventures of Superman*?

6.

How many years old is Duncan MacLeod in *Highlander: The Series*: a. 400 b. 500 c. 600?

7.

In what city does Angel run his detective agency in the *Buffy the Vampire Slayer* spin-off, *Angel*?

8.

Are You Afraid of the Dark? is about a group of teenagers who meet in the woods at night to tell stories. What do they call themselves?

9.

In *The Secret World of Alex Mack*, an experimental chemical gives Alex powers including telekinesis, shooting electricity from her fingers, and the ability to do what?

10.

What are the names of the three witchy Halliwell sisters in *Charmed*?

THE
X-FILES

"THE TRUTH IS OUT THERE"

Quiz 42

1.
What is the name of Mulder's sister, who he believes was abducted by aliens?

2.
Walter Skinner, played by Mitch Pileggi, held what position within the FBI?

3.
Who is credited as the creator of *The X-Files*?

4.
Name the fictional brand of cigarettes that the Cigarette Smoking Man prefers.

5.
The alien virus Purity is more commonly referred to as what oil?

6.
By what name are private investigators John Fitzgerald Byers, Melvin Frohike and Richard Langly collectively known?

7.
Which episode of *The X-Files* was so shocking that network Fox refused to re-air it for three years after its initial broadcast:
a. "The Host" (Season 2)
b. "Home" (Season 4) or
c. "Grotesque" (Season 3)?

8.
Between which two seasons do the events of the first X-Files movie, *Fight the Future*, take place?

9.
What is the phrase that appears on the UFO poster that hangs above Mulder's desk?

10.
What is the name of the secretive and powerful shadow organization to which the Cigarette Smoking Man and the Well-Manicured Man both belong?

SO YOU THINK
YOU KNOW ...

STAR TREK

NEXT GEN, DS9 & VOYAGER

Quiz 43

1.
What is the name of *Next Generation*'s android character, played by Brent Spiner?

2.
Jean-Luc Picard is captured and assimilated by what alien group of cybernetic organisms?

3.
Boy genius Wesley Crusher was a notably unpopular character played by who?

4.
Deep Space Nine was a departure from the USS *Enterprise*. To what does the series title refer?

5.
Name one of the two *Next Generation* characters to permanently transfer to *Deep Space Nine*.

6.
What is the name of the Frank Sinatra–like hologram who often helps *Deep Space Nine* characters with their personal problems?

7.
What is the Cardassian name for Deep Space Nine?

8.
Voyager was the first *Star Trek* series to feature a female commanding officer as a central character. What is her name?

9.
Voyager is stranded in the Delta Quadrant while searching for a missing spacecraft belonging to what group?

10.
Who replaces Kes in Season 4?

SO YOU THINK YOU KNOW ...

SCI-FI

Quiz 44

1.
Starring Vanessa Angel as a computer simulation brought to life, *Weird Science* was adapted from a 1985 film by which director?

2.
In *seaQuest DSV*, what type of animal is Darwin?

3.
In *Red Dwarf*, Arnold Rimmer has what letter in the middle of his forehead?

4.
In *Futurama*, Philip J. Fry falls into a cryogenic pod and wakes up in what year?

5.
What is the name of the Solomons' mission leader and king of the universe in *3rd Rock from the Sun*?

6.
Who played scientist Quinn Mallory in *Sliders*?

7.
The title of *Babylon 5* refers to what: a. a planet b. a space station c. a wormhole?

8.
The animatronic puppets in *Farscape* were created by Creature Shop, part of which legendary production company?

9.
True or false? Steve Carell guest starred in *Quantum Leap* as Buddy Holly.

10.
A sequel to a 1994 Roland Emmerich film, what is the show about an elite U.S. military team that explores the galaxy via ancient alien devices that can connect across space?

SO YOU THINK
YOU KNOW ...

CATCH-
PHRASES

NAME THAT SHOW!

Quiz 45

1.
"I'm the baby,
gotta love me"

2.
"Sweetie darling"

3.
"Make it so"

4.
"MMMHHMMM!
I do, I do, I do-oooh!"

5.
"A damn fine cup of coffee!"

6.
"I am Cornholio!"

7.
"Serenity now!"

8.
"Eat my shorts!"

9.
"How you doin'?"

10.
"Did I do that?"

Answers

QUIZ 01: 1. Chicago, Illinois 2. Dr. Phil 3. Michael Jackson 4. *The Deep End of the Ocean* by Jacquelyn Mitchard 5. The Lifetime Achievement Award at the Daytime Emmys 6. Eye color — Jane Elliott began this exercise with her third-grade class in 1968, the day after the assassination of Dr. Martin Luther King Jr. 7. Harpo 8. Harpo is "Oprah" spelled backwards 9. Mad Cow 10. Tina Turner

QUIZ 02: 1. 24 2. *The Montel Williams Show* 3. Gabrielle Carteris 4. Red 5. c. Quincy Jones 6. Nice 7. True 8. Povich 9. *Can We Shop?* 10. Geraldo Rivera

QUIZ 03: 1. Minneapolis, Minnesota 2. West Beverly Hills High School 3. Brenda and Kelly 4. She was caught being drunk at prom 5. Dylan McKay 6. The Peach Pit 7. Donna Martin (played by Tori Spelling) 8. Season 4 9. Hilary Swank 10. Donna and David

QUIZ 04: 1. Pittsburgh, Pennsylvania 2. Jordan Catalano 3. 15 4. False (but the role almost went to Alicia Silverstone) 5. Grateful Dead 6. b. Embryos 7. *Wicked* 8. Ecstasy 9. One (it was cancelled abruptly by ABC) 10. Rickie Vasquez

QUIZ 05: 1. Paul Feig and Judd Apatow 2. The mathletes 3. Her grandmother 4. Drums 5. *The Bionic Woman* 6. Busy Philipps 7. *Dungeons & Dragons* 8. Sam 9. c. ventriloquism 10. Grateful Dead

QUIZ 06: 1. A filmmaker 2. Capeside 3. His English teacher, Ms. Jacobs 4. Our lives to be over 5. The Icehouse 6. New York 7. McPhee 8. *Les Misérables* 9. Sheriff 10. *E.T.*

QUIZ 07: 1. Basketball 2. Lose 3. Orange soda 4. *Boy Meets World* 5. Screech 6. Mila Kunis and Ashton Kutcher 7. *Sweet Valley High* 8. A baby alligator 9. a. at summer camp 10. Mayim Bialik

QUIZ 08: 1. Alaska 2. New York 3. John Corbett 4. Maurice J. Minnifield 5. A moose 6. Satellite 7. The Brick 8. a. One Who Waits 9. Walt Whitman 10. Ostriches

QUIZ 09: 1. Cook County General Hospital 2. True 3. Noah Wyle 4. It was filmed and broadcast live 5. Carol Hathaway 6. Dr. Peter Benton 7. b. Quentin Tarantino 8. California 9. Eclampsia 10. George Clooney

QUIZ 10: 1. Andrew Davies 2. Six 3. The United States 4. Jane, Elizabeth, Mary, Kitty and Lydia 5. *Bridget Jones* 6. Netherfield 7. Anna Chancellor is a direct descendant of Jane Austen's brother Edward 8. True 9. *Absolutely Fabulous* 10. Lady Cutherine de Bourgh

QUIZ 11: 1. Red 2. California 3. "I'm Always Here" 4. Lt. Stephanie Holden 5. *Baywatch Nights* 6. Volleyball 7. True 8. Michelle Williams 9. a. Yasmine Bleeth 10. Matt Brody

QUIZ 12: 1. Salinger 2. A swimming pool 3. *Felicity* 4. a. 6 5. Jane Seymour 6. Dr. Melfi 7. True 8. Nine 9. *Chicago Hope* 10. President Josiah Bartlet

QUIZ 13: 1. Princess Leia 2. New York 3. A ring 4. b. she sends him a fax 5. McDonald's 6. Autolycus 7. Mabel 8. 2000 9. Season 5 10. Their high school graduation

QUIZ 14: 1. Adam Schiff 2. Donald Cragen 3. The Manhattan District Attorney's Office 4. Dick Wolf 5. False 6. Dr. Elizabeth Olivet 7. Chris Noth 8. His daughter 9. *Law & Order: Special Victims Unit* 10. J.K. Simmons

QUIZ 15. 1. 15th 2. Season 2 3. Det. Diane Russell 4. The Vietnam War 5. False 6. David Milch 7. She kills Marino 8. Apple 9. Capt. Haverill 10. Theo

QUIZ 16: 1. Boston, Massachusetts 2. Cage and Fish 3. It is unisex 4. Subzero Nelle 5. Lucy Liu 6. Barry White 7. Baby 8. "Hooked on a Feeling" 9. Billy Thomas 10. The face

QUIZ 17: 1. Crimes related to the U.S. Military 2. b. a forensic pathologist 3. *New York Undercover* 4. Two pairs of police officers' feet, walking away along a cobbled street 5. *Frost* 6. David E. Kelley 7. Chuck Norris 8. Stanley Tucci and Patricia Clarkson 9. Hot dogs 10. True

QUIZ 18: 1. *Days of Our Lives* 2. Fashion 3. Ramsay St. 4. *General Hospital* 5. Harmony 6. *Another World* 7. *Santa Barbara* 8. *The Young and the Restless* 9. London 10. False

QUIZ 19: 1. West Philadelphia 2. Two 3. Jazz 4. "It's Not Unusual" by Tom Jones 5. Don Cheadle 6. He thinks he's won the lottery 7. b. bungee jumping 8. A pirate 9. False (her song is called "Make Up Your Mind") 10. Boyz II Men

QUIZ 20: 1. She was there 2. Niles 3. Three 4. C.C. Babcock 5. Ray Charles 6. a. Beverley 7. "The Thing" 8. False (she's played by Renée Taylor) 9. Val 10. *Cats*

QUIZ 21: 1. Barone 2. Police officer 3. Geoffrey and Michael 4. Tuna 5. His chin 6. False (she worked in PR) 7. *Newsday* 8. A futon 9. Condoms 10. Peter Boyle

QUIZ 22: 1. c. *Wake Up, San Francisco* 2. *Blossom* 3. *Brotherly Love* 4. Tamera 5. *Perfect Strangers* 6. "The Tool Man" 7. A horse and carriage 8. Brandy 9. Suzanne Somers 10. Topanga

QUIZ 23: 1. Cosmo 2. A Junior Mint 3. George 4. His girlfriend 5. Grievances 6. *Schindler's List* 7. Bosco 8. George's shirt button 9. Her nipple 10. Bryan Cranston

QUIZ 24: 1. French and Saunders 2. Bubble 3. Bollinger 4. Saffy 5. Public relations 6. a. 1973 7. True 8. Gynecologist 9. Marianne Faithfull 10. The stupid people

QUIZ 25: 1. Marcel 2. Because that's when his parents announced their divorce 3. Ursula 4. Ken Adams 5. Her apartment 6. That Ross is in love with her 7. c. an actor 8. A Troll Doll 9. Ugly Naked Guy 10. Tom Selleck

QUIZ 26: 1. Seattle, Washington 2. False 3. "I'm listening" 4. KACL 5. Manchester, U.K. 6. Cafe Nervosa 7. The Elliott Bay Towers 8. *Cheers* 9. Attorney General of Wisconsin 10. Eddie

QUIZ 27: 1. Richard Curtis 2. b. Teddy 3. His watch 4. The other man on the beach is blind 5. A Mini 6. Steak tartare 7. It has three wheels 8. On a roller coaster 9. False 10. With his sock

QUIZ 28: 1. Interior designer 2. Danny 3. Debbie Reynolds 4. Guapo 5. Columbia 6. Jack 7. True 8. Michael 9. Her water bra 10. Stanley Walker

QUIZ 29: 1. Brooke Shields 2. Chicken pot pie 3. Cleveland, Ohio 4. *Flavor* 5. Their first 6. Basketball 7. Deputy Mayor of New York 8. Martin Lawrence 9. False (Seinfeld does appear in an episode, playing himself) 10. Joe Rogan

QUIZ 30: 1. *Frasier* 2. The Rembrandts 3. True (he has been nominated four times) 4. *Captain Planet and the Planeteers* 5. *Dawson's Creek* 6. PRIMUS 7. *Twin Peaks* 8. *Charmed* 9. c. Nerf Herder 10. Tony Soprano

QUIZ 31: 1. Phil and Lil 2. Saturn 3. Toy inventor 4. They are cousins 5. True 6. Chuckie 7. Reptar 8. A screwdriver 9. *All Grown Up!* 10. Susie's

QUIZ 32: 1. Warner Bros. 2. A water tower 3. Max 4. Try to take over the world 5. The Goodfeathers 6. Yakko, Wakko and Dot 7. Green 8. Mindy 9. "Pinky and the Brain" 10. Steven Spielberg

QUIZ 33: 1. Michelangelo 2. Mandark 3. Earth, wind, water, fire and heart 4. False (Ipkiss is voiced by Rob Paulsen) 5. *Pokémon* 6. *TaleSpin* 7. Kamehameha 8. Mark Hamill 9. A wallaby 10. Mayonnaise

QUIZ 34: 1. The Stonecutters 2. Poochie 3. A donut 4. Towel 5. Conan O'Brien 6. Maggie Simpson 7. The aurora borealis 8. An Esquilax 9. Patty and Selma Bouvier 10. Paul McCartney

QUIZ 35: 1. Greg Daniels 2. A whooping crane 3. The Mega Lo Mart 4. Texas 5. Rusty Shackleford 6. Propane and propane accessories 7. A new truck 8. Matthew McConaughey 9. False 10. Lady Bird

QUIZ 36: 1. Morgendorffer 2. *Beavis and Butt-Head* 3. Lawndale High 4. Upchuck 5. Dave Grohl 6. The Fashion Club 7. *Sick, Sad World* 8. Mystik Spiral 9. Peanuts 10. Her navel

QUIZ 37:
1. c. Squigglevision 2. True 3. A chihuahua 4. *Æon Flux* 5. Private detective 6. The Gruntmaster 6000 7. MTV 8. Hanna-Barbera 9. Quahog 10. *Todd McFarlane's Spawn*

QUIZ 38: 1. The FBI 2. One Eyed Jacks 3. Ghostwood 4. The Log Lady 5. Plastic 6. The red room 7. Tying a cherry stem in a knot using her tongue 8. R 9. Smiling bag 10. Double R Diner

QUIZ 39: 1. The Hellmouth 2. She burned down the gym 3. Giles 4. True 5. Kendra 6. The Scooby Gang 7. b. art gallery manager 8. Mister Pointy 9. His soul 10. The Gentlemen

QUIZ 40: 1. *Hercules: The Legendary Journeys* 2. b. Destroyer of Nations 3. Renee O'Connor 4. New Zealand 5. Bruce Campbell 6. The chakram 7. An Amazon Queen 8. Princess Diana 9. Hope 10. Argo

QUIZ 41: 1. Tess 2. Her 16th 3. His wicked stepmother Hera 4. R. L. Stine 5. Teri Hatcher and Dean Cain 6. a. 400 7. Los Angeles 8. The Midnight Society 9. Dissolve into a puddle of liquid 10. Prue, Piper and Phoebe

QUIZ 42. 1. Samantha 2. Assistant Director 3. Chris Carter 4. Morley 5. Black 6. The Lone Gunmen 7. b. "Home" (Season 4) 8. Seasons 5 and 6 9. "I Want to Believe" 10. Syndicate

QUIZ 43: 1. Data 2. The Borg 3. Wil Wheaton 4. A space station 5. Worf or Miles O'Brien 6. Vic Fontaine 7. Terok Nor 8. Captain Kathryn Janeway 9. The Maquis 10. Seven of Nine

QUIZ 44: 1. John Hughes 2. A dolphin 3. H (for hologram) 4. 2999 5. Big Giant Head 6. Jerry O'Connell 7. b. a space station 8. The Jim Henson Company 9. False 10. *Stargate SG-1*

QUIZ 45. 1. *Dinosaurs* 2. *Absolutely Fabulous* 3. *Star Trek: The Next Generation* 4. *Kenan & Kel* 5. *Twin Peaks* 6. *Beavis and Butt-Head* 7. *Seinfeld* 8. *The Simpsons* 9. *Friends* 10. *Family Matters*

"HOW YOU DOIN'?"

Published in 2023 by Smith Street Books
Naarm (Melbourne) | Australia
smithstreetbooks.com

ISBN: 978-1-92275-486-8

Smith Street Books respectfully acknowledges the Wurundjeri
People of the Kulin Nation, who are the Traditional Owners of the
land on which we work, and we pay our respects to their Elders
past and present.

The moral right of the author has been asserted.

Publisher: Paul McNally
Text: Hannah Koelmeyer
Editor: Rosanna Dutson
Designer: Vanessa Masci
Layout: Megan Ellis
Project manager: Hannah Koelmeyer
Cover illustration: Paul Borchers
Proofreader: Sophie Dougall

Printed & bound in China by C&C Offset Printing Co., Ltd.

Book 290
10 9 8 7 6 5 4 3 2 1